701.18 DAY

MAY - - 2018

HOW **ART**
CAN MAKE
YOU **HAPPY**

HOW **ART**
CAN MAKE
YOU **HAPPY**

BRIDGET WATSON PAYNE

CHRONICLE BOOKS
San Francisco

Library of Congress Cataloging-in-Publication Data:
Names: Payne, Bridget Watson, author.
Title: How art can make you happy / by Bridget Watson Payne.
Description: San Francisco : Chronicle Books, 2017.
Identifiers: LCCN 2016021862 | ISBN 9781452153223 (alk. paper)
Subjects: LCSH: Art appreciation.
Classification: LCC N7477 .P39 2017 | DDC 701/.18—dc23 LC record
available at https://lccn.loc.gov/2016021862

Manufactured in China

Designed by Vanessa Dina

10 9 8 7 6 5 4 3

Chronicle Books LLC
680 Second Street
San Francisco, California 94107
www.chroniclebooks.com

Chronicle books and gifts are available at special quantity discounts to
corporations, professional associations, literacy programs, and other
organizations. For details and discount information, please contact our
premiums department at corporatesales@chroniclebooks.com or at
1-800-759-0190.

ART IS MAGICAL

Once upon a time you loved art. Or else you want to discover art now. It's safe to assume one or the other of those things about you, right? Presumably the reason you're reading a book called *How Art Can Make You Happy* right now is that you either once had, or aspire to have, a happy romance with art. Maybe the love went astray or maybe you can't figure out how to get it off the ground in the first place. Maybe you used to go look at art in museums and galleries but you no longer make that a priority. Or maybe you want to do one or the other or both of those things but are afraid to start.

And none of this is making you any happier. It's not as if you intentionally decided, "You know what? Art is taking up too much of my time and energy. I'm going to let it go out of my life and then I will feel better, freer!" No. You're not only living a life that feels diminished by the absence of art in it, but you're also stuck hauling around an unpleasant load of guilt over how you should be having art in your life, but don't.

So that when you happen to have coffee with that one friend of yours who actually does go out to exhibitions and is knowledgeable about artists, you find yourself

doing what guilty people do—bemoaning, making excuses, bemoaning some more—not because your friend cares a bit whether you did or didn't make it out to the latest blockbuster show at the museum, but because you care. You care more than you care to admit. And you don't know how to fix it.

But here's the thing: Contrary to the impression you may gather from any number of sources—ranging from the art press to your grandma—art should bring happiness to your life. Let's say that one more time: **Art should bring happiness to your life.** ✓

Is art always happy? No, of course not. No more than it's always pretty, comfortable, or easy. But can engaging with art—with art's potent brew of visual pleasure, intellectual rigor, myriad meanings, and unexpected worldview—make you a happier human being with a profoundly enriched life?

Resoundingly, the answer is: Yes.

Here's how.

WHAT IS ART ANYWAY?

"Art" is a big word, and it's not really safe to assume we all mean the same thing when we say it. For instance, there are still loads of people, if you can believe it, hung up on the idea that things like craft or fashion design can't be art and shouldn't be shown in art museums.

This book takes a broad-minded approach to the concept of art. For our purposes, art includes but is not limited to: paintings that hang on walls; sculpture, performance, video, sound, installation, and street art; performing arts such as dance, music, and theater; things not traditionally considered art (like the aforementioned craft and fashion) but elevated to the level of art by their practitioners; literature, poetry, and really good essays; and amateur art made by regular people.

However, for some reason it seems to be visual art that induces the most guilt. Perhaps this is because it's so tied up with sightseeing—you're *supposed* to want to go to the Louvre when you're in Paris. Guilty visual-art lovers have the perception that people who care about other art forms (the performing arts, for instance) just buy the tickets and go out and see the band or the play or whatever it is that floats their boats. But there are guilty music lovers and guilty theater lovers, too.

WHY LOOKING AT ART WILL MAKE YOU A HAPPIER HUMAN BEING

ART IS MAGICAL

Yes, art is magical. Studies show that looking at art stimulates, among other things, the motor cortex, the part of your brain that controls your body's movements. When you look at art you don't just see it with your eyes or feel it with your brain, you also feel it with your whole body. Quite literally: **Every fiber of your being—your senses, your intellect, your emotions, even your physical corpus—responds to works of art.** So that right there is pretty much the first magical property of art. It zings through you like a bolt of lightning.

Perusing more science brings to light more magic. One study demonstrated that looking at landscape paintings, and particularly seascapes, not only reduces stress but can actually speed up physical healing after surgery. The link between creativity (and the making of art in particular) and happiness is well established (despite the archetype of the tortured artist).

But that's not all. Art wakes you up to three profoundly important realities. Cognizance of any one of these realities alone can make you a much happier person. Together, they form an almost intoxicating brew of enhanced well-being. They are:

One, the reality of the world.

Two, the reality of other people.

Three, the reality of yourself.

"You need to let the little things that would ordinarily bore you suddenly thrill you."

–ANDY WARHOL

The world around you is spectacular. And not just the big things, the oceans and the sunsets and the Eiffel Tower and whatnot. Like Andy said, if you let yourself, you can see just as much wonder in the little stuff. The Campbell's soup can, the autumn sun on bricks, the eyelashes of a giraffe. Tuning in to the magnificence of reality, both natural and manmade, can increase your daily happiness quotient.

Great thinkers—from poets to psychiatrists, philosophers to scientists—have known this to be true. One of the best treatments for ailments from vague malaise to serious depression and everything in between—isolation, grief, boredom, creative block, the blues—is to step outside the front door. Go to the ocean. Go to the

corner café. Allow people or objects or nature to actually enter in through your eyeballs and make an impression on your brain. Start to see their beauty and you start, teeny tiny bit by teeny tiny bit, to bring more joy into your heart.

But how? Your brain is massively good at blocking things out—it has to be. A major part of the job of your consciousness is to make sure you remain unconscious of most of what's around you most of the time. Otherwise you'd be paralyzed by stimuli. If it's not going to hurt you or eat you, or if you can't eat it, or reproduce more tiny humans with it, the lizard in your brain doesn't want you to bother about it. How can we fight that? How can we combat eons of deliberate blindness in the aid of survival? **How can we punch a hole in the barrier separating us from the glowing heart of things? You know the answer: Art.**

Sometimes stepping outside and looking at manhole covers and clouds is not enough. Our brain is too conditioned, too certain that the random flotsam and jetsam of physical life are not important, too well trained at blowing them off. We need a guide. Someone who

has come before and seen the world in the way only that particular person could, and then taken what he or she saw and from it created something no one else could have created. And when you look at that thing, the magic is twofold (actually, it's about a millionfold, but we're talking about the first two folds for now)—you see both the beauty this person has made, in front of you, and you also see, through it, into the wider world that inspired it. The world that is still out there right now.

Which is not to say that all art looks like the world, or even that all art is inspired by physical reality. Of course it doesn't and isn't. And we'll get to all of that in just a moment. Nor is any of this to say that art is a utility. Feeling glum? Throw the art switch! No. That's not how it works. One of the greatest properties of art is that it's not *for* anything. It's not there to make you feel better. Indeed, it may unsettle you, make you feel worse. But it will almost always make you *feel* (even if what you feel is that this particular art is not for you). And, if you let it, it will almost always make you *see*. And seeing is what it's all about.

"The hardest thing to see
is what is in front of your
eyes."

–FRIEDRICH SCHILLER

Let's face it: We're all limited. Terribly, unavoidably
limited. We are limited by the time and place and soci-
ety we were born into—limited by race and class and
gender assumptions, limited by privilege, limited by lack
of privilege, limited by things we were taught as children,
limited by language, limited by the range of light our
human eyeballs can sense, limited by a million things we
can do relatively little—if indeed anything—to alter. So,
yeah, limited to an almost tragic degree. Each and every
one of us, every single day.

But **humankind has in its long and tumultuous
history created one great and blazing invention
to get ourselves beyond our own limitations**
and, hint, it's not the Internet. It's art. It's painting and
sculpture and music and literature and dance and on
and on and on.

We all know, or at least strongly suspect, that in creating art the artist transcends some of his or her inevitable human limitations. We love the story of the ecstatic genius artist driven nearly mad when the doors of perception are blown wide open by the magic of his or her own creative power—Gauguin finding his inspiration in the South Seas, O'Keeffe finding hers in the desert, Pollock breaking through to the next level of abstract painting in a garage.

And, yeah, rad. Good for them. Go, artists! But what we seem to talk about much, much less often is how experiencing art can break us out of our own little cages. And we don't have to be creative geniuses for that to happen; we just have to get out of our own gosh-darn way and let ourselves see.

"The gloom of the world
is but a shadow. Behind
it, yet within our reach,
is joy. There is radiance
and glory in the darkness
could we but see—and to
see we have only to look.
I beseech you to look!"

–FRA GIOVANNI

So, let's talk about two things you might see quite a bit of
when you walk into a number of different kinds of major
museums: European painting from the past five hundred
years or so, and black-and-white photography from the
twentieth century. These two have more in common
than you might at first think. For one thing they both, by
and large, tend to be concerned with representation.

There is, of course, the very valid argument to be made that true representation is impossible. Nevertheless many paintings and photographs from these eras, when you look at them, seem to be shouting to you very loudly that they are in fact showing you how things *are* (or rather how things *were*), what they *looked* like. Artists represented—often very skillfully, often with passion—how clothing hung on bodies in the times and places they lived; how the trees and houses in the background were shaped; how the shadows of pedestrians walking on the sidewalk refracted onto the wall they were passing by. They took the stuff of life and made their art out of it, as surely as they made it out of paint and canvas or cellulose and emulsion.

Entering a museum gallery can feel like walking into a crowded classroom: Every kid wants your attention; everyone wants to pull your focus to what *they* have to say. And they all have a million things to say—about love, about religion, about wealth and power and status, about technical virtuosity and show-manship, about profound moral striving and failure, about fantasy, magic, shape, light, shadow, perspective, wonder, despair, sacrifice, and more and more and more. But perhaps, just perhaps, sometimes they all say one thing louder than any of the rest: Look! This is the world! Open your eyes and see it!

"To be modern is to let imagination and invention do a lot of the work once done by tradition and ritual."

–ADAM GOPNIK

And then, seemingly all of a sudden, it all gets cracked wide open—Turner, impressionism, cubism, abstract expressionism, and pretty much everything since. Bang! Let's not worry anymore about what things look like in the world; let's acknowledge that human insight was always at best a very flawed engine for the "perception" of "reality," and let's think instead about how they look to that artist, how the artist perceives the world, the artist's individual impressions, and how those in turn might be abstracted. And so we get the story we all know visually—the movement throughout the nine-teenth and twentieth centuries away from art that looks

like the world and toward art that does not look like the world.

But lord knows you don't have to be looking at something that looks literally just like the world in order to have your eyes opened for you. Once art—any art, be it the exquisite realism of a Vermeer or the wild abstraction of an enormous mural spray-painted in an alley just last week—has done its number on you, you will see everything, not just things like the art you saw, more clearly.

It's like coming out of a darkened movie theater and being amazed that there's still daylight out—**for a moment, everything sparkles.** And what do you know, Turner really did have a point about sunsets. And you really can almost see the lady's face from all angles at once because she talks to you, she *moves*, she's never static. And the soup can glimmers in all of its mundane beauty—and maybe you have subversive thoughts about capitalism and maybe you don't. But either way, you are thinking and you are seeing. The light has come on.

"This is the only note to self: Other people are real. That's all there is to learn. It takes forever, but you can start now."

–FRANK CHIMERO

We all start off as toddlers. Well, ok, we actually all start off as zygotes, then babies, then toddlers. But the basic premise holds: We all start off as selfish. Deeply, essentially, profoundly self-centered. Famous developmental psychologist Jean Piaget was one of the first people to point out how deeply egotistical small children are, and *should be*. That it is age appropriate. That part of growing up is learning to see things from other people's point of view. Learning to believe that other people's feelings are truly the same to them as ours are to us. This is absolutely not something we are born with, it's

something we must struggle to learn over a long period of time. Indeed, as Frank Chimero says, maybe even over the course of our entire lives.

The nineteenth-century writer George Eliot isn't much appreciated these days, but this was her profoundest contribution to human wisdom: that **the cultivation of empathy is our true and proper human work**, and that the very best of us are still working away at it well into mature adulthood. Because it is freaking hard. We all still have a toddler somewhere inside who is profoundly uninterested in how anyone else feels. And have you ever tried to get a toddler to do something they don't want to do? Yep. Hard.

So, you may be asking yourself, what the heck does this have to do with art happiness? Answer: Everything. If empathy is one of the greatest sources of deep human happiness (as opposed to the fleeting happiness of, say, a beer and a Mars bar), art is a wellspring of empathy.

Imagine if you could call anyone on a magic videophone.
Anyone at all. Anywhere in the world. Living or dead.
Colossally famous or notoriously reclusive. Smart, funny,
dreamy, crazy. And you could ask this person to show
you what life was or is like for them. How they saw the
world. What it was like to live inside their skin and walk
in their footsteps at any given moment of human history,
on any continent, ever. And they would show you. They
would show you how people in their time and place
thought and saw and felt, but even more than that they
would turn their own innermost beings inside out and
show you what it was like to be them and only them—
their feelings, their perceptions, their preoccupations,
their very selves. One after another after another.

You know what that's a description of? Seeing art. When
you look at a piece of art you are seeing the reality of
the person who made it. If you think about it, you can
be left with little doubt in your mind: This person was
real. As real as you are. This person was the center of
his or her own universe as surely as you are the center
of yours. This artist had unique perceptions and unique

ways of expressing those perceptions that no one else alive before or since has ever had or will ever have. **There is no surer proof of the reality of others than the things they actually create.**

Now, of course, there's a major problem with this. Up until very recently (and in many ways still, even including very recently) you could not actually call up just "anyone" on the magic art telephone. You could only summon the reality of the people who'd been lucky enough to be included as "Artists," people in the canon. And those people were overwhelmingly male and overwhelmingly white. The prejudices of the past, and indeed the ongoing prejudices of the present, mean we don't have access to the reality-proving creative output of nearly as many different kinds of people as we should have. And that is a tragedy. But the limited sampling we do have still proves a profound point: Whatever you are looking at, the person who made this art was real.

The People Depicted in This Art Are Real

There are any number of cases where the people depicted in art are obviously literally real: Renaissance portrait paintings, Civil War tintypes, Diane Arbus photographs, Jeff Koons's Michael Jackson statue. **A person who lived and breathed and loved and hated and cried and napped is looking out at you from across space and time.** If you let it, that can blow your mind a little.

But this magic holds true even when the art in question depicts not actual people, but fictional people, or landscapes, or blobs. Because the emotions are real. To which you may reasonably respond: Huh?

It's an argument people have a lot about the glowing rectangles of color in the paintings of Mark Rothko. Person one is *not* excited about Rothko. "They're just colored boxes," says person one. "No, no!" says person two, "They're so much more! I mean, yes, of course they are colored boxes. But they glow! They are sea and sky and trees. They are the world, and light, and nature! They are *feelings*." "Nope," says person one, "I still just see boxes. Fuzzy boxes." And it's not that one person is right and the other is wrong (we'll get into matters of taste before long), but rather simply that for person two Rothko has successfully imbued his colored boxes with real human emotion. A Rothko can be as real a vehicle for empathy as an Arbus.

Last stop on our tour of the art-as-empathy engine is
a little thought experiment. Imagine, for a moment, a
picture hanging on a museum wall. Imagine the thou-
sands, or even millions, of people who have walked past
it. Some have been profoundly moved by it, some have
been mildly interested, and some have blown past, hun-
gry for lunch. Then back up further and suppose this is
a very famous picture. Imagine all the people who have
seen it in books. Imagine all the people who have seen
it online. Imagine all the people who have seen it on
mouse pads and oven mitts and posters in their dentists'
waiting rooms. When you look at this picture you are
connected not only to the reality of the artist who made
it, not only to the reality of whomever or whatever it
depicts, but also to the reality of the millions of other
people who have seen it, just like you are doing. **You
may be alone, but you are also together.** They
were real. Just like you. That's all there is to learn.

"That everything-all-at-once feeling that you're burning the candle from both ends and out the middle."

—BRIGID SCHULTE

So, if we're all selfish toddlers inside, we don't really need to worry about believing in or appreciating the reality of ourselves, do we? Surely, if anything, the problem is that we are too self-centered, never not self-centered enough. Right? Well, yeah. Except.

Except that we also all have lizards in our brains—the oldest, prehistoric part of the human mind—telling us to do nothing but survive. Except that we all have the myriad cultural limitations discussed earlier inevitably holding us back in a million ways. Except that in our day and age nearly everyone seems to be in a near-constant state of profound overwhelmed-ness. The feeling that we are always tired. Always stressed. That there is

never enough time in the day to do the things we need to do, never enough time for our friends and families, let alone for ourselves.

Art has the power to take you out of the endless circling thoughts of your day-to-day, just-getting-by self—the hamster wheel inside your head. It has the power to break through your bad habits of mind, your fretting, your pettiness. This is the third way art puts you in touch with reality, and thus makes you happier than when you are disconnected from reality: It awakens you to the reality of your better self. **Your happier, more profoundly alive self.**

A lofty claim? Oh yes. But if ever there was a subject that inspired, and then turned out to truly deserve, lofty claims, that subject is art.

"We cannot selectively numb emotions; when we numb the painful emotions, we also numb the positive emotions."

–BRENÉ BROWN

At the risk of preaching to the choir here (you'd hardly be reading this book if you didn't believe on some level that art has the power to make you feel), it bears baldly stating: When you really do it, **looking at art can awaken your emotions in a way that is profoundly good for you.** It can also be profoundly unsettling. And that's a good thing.

It can be tempting to dismiss art's power to evoke emotions. We've all had the experience of looking at a work of art and feeling absolutely nothing—not even as strong an emotion as dislike bubbled up; we looked at this thing and felt … blank. Just because art *can* make you feel

profoundly doesn't mean it always will. Not every work of art will evoke feelings in every person on every occasion. But even if it only happens one in twenty times, or even one in a hundred times, it's still such a potentially valuable part of human existence as to make chasing that one-in-a-hundred time very well worth your while.

Some art is rigorously intellectual. Some is decoratively pretty. But all of it carries within itself the capacity to make you think. To wake up your brain to implications and nuances—of history, of politics, of aesthetics, of ethics—that you might not otherwise have considered. What's the deal with that mysterious smile? What's the deal with three-point perspective? What's the deal with consumerism? What's the deal with Andre the Giant? Intellectual work is not always comfortable. But if we are seeking to be **happy in its deeper sense (as opposed to merely jolly or cheerful or satiated)**, then exercising our brains, feeling them pulled and stretched by imperatives other than our own, thinking different thoughts today than the thoughts we thought yesterday, is a very good way to go.

Willem de Kooning's terrifying women. Damien Hirst's pickled cow. Kara Walker's brutal-yet-beautiful paper cut-outs. Make no mistake. All this talk about art making you *happy* doesn't mean it will always make you feel *good*. **You will be shaken up. You will be unsettled. You will even be afraid, and sad, and ashamed, and angry.** You might occasionally want to barf.

But as anyone who enjoys roller coasters, or horror movies, or bondage, or eating too much Thanksgiving dinner can tell you: None of those emotions preclude the experience of pleasure. The Greeks knew this when they came up with the concept of *catharsis*—how feeling bad can make you feel good. Teenagers in the '80s knew this when they railed against Tipper Gore trying to take away their raunchy music lyrics. But it's rare that anyone admits it about art.

We tell ourselves that art is supposed to live in a rarefied atmosphere where the experience of pleasure is very much not the point.

But what do we think has kept us coming back, year after year, millennium after millennium, to the making of, and the looking at, art, if not pleasure? We like it. It makes us feel delight. Even when it makes us feel bad. We're complicated that way.

HOW TO
FIND THE ART
YOU LIKE

So, you're on board with the idea that looking at more art would make you a happier human. And pretty soon we'll talk about all the different places and ways you can go and do that—like, the actual logistics of it. But before you head out the door there's one major conundrum to be solved: How do you know what you like? Yes, *what do you like?*

Because embedded in that seemingly simple question is actually a pretty subversive notion—namely that **it matters what you actually, personally, *like*.** That you should be going out and looking at stuff, not because it is the important stuff that this or that person—the newspaper art critic, the museum curator, the culture blogger, your college art history professor, your mom—says you *should* be looking at (should be admiring, should be appreciating, should be talking about, should be familiar with, so that when other people talk about it you don't feel stupid), but rather because, gosh darn it, you *like* it.

We all remember liking, right? As in, the way you like a boy or a girl when you're a teenager, like you *like* them like them. It might make you giddy, it might make you vaguely nauseous, but the main point is that it makes you feel, and feeling that feeling of feeling feels good. It's an art crush. That's art happiness, right there. And to find it you must become your own tastemaker.

"Anything or anyone that does not bring you alive is too small for you."

–DAVID WHYTE

There's a lot to be said for the concept of the taste-maker. Someone who spends a lot of time looking at and thinking about art—be they a gallerist, curator, arts journalist, art blogger, or collector—is going to be familiar with a ton of artists and their work and, as such, is going to be able to introduce you to loads of things you might not have stumbled upon on your own. Which is great, cool. That's a resource, and by all means, use it.

But here's the thing: **Only you can know when a work of art is working for you.** Only *you* know what you like. Only *you* know what gives you pleasure. Only *you* know what makes you think and feel and see. Someone else can only make your taste if you let them. And they can never make it as well as you can yourself. So why let them?

Trust yourself. Trust your taste. Trust your capacity to cultivate and grow and develop and *make* your own taste. Take recommendations from others, sure, but ultimately allow the buck to stop with you yourself. Have the courage to articulate to yourself what you do and do not like. Have the courage to challenge and stretch yourself. And ultimately have the courage to be your own tastemaker.

In practical terms, being your own tastemaker means learning to trust your instincts. What instincts are those, you might ask? Oddly enough, the metaphors for understanding such instincts are nearly always bodily, such as the fanciful notion that there are certain receptors in your brain that certain works of art—and only those certain works of art—can fit into. Or that certain works of art jump out at you and sear themselves into the back of your retinas. That certain artworks give you chills, make you gasp, make your jaw drop.

These are the same quasi-physical instincts that tell us when we're romantically attracted to someone, when someone would make a good friend for us, when to take a gamble, when a job's worth staying at, when **things are about to get a whole lot more interesting.**

Some people are a lot better at trusting their instincts than others. But nearly everyone could use a bit of practice at trusting them when it comes to matters of aesthetic taste. We've all heard it said so many times that liking this or that thing—jazz, white walls, dry white

wine—marks us out as smart and sophisticated that we have a really hard time not believing it. But deep down we *know* what we like and what we don't like—the same way we know whether we like or dislike mushrooms. We know what gives us a thrill and what doesn't. What we agree is amazing and what we secretly think is overrated. And that's what we should practice trusting.

Does this mean we should never stretch ourselves? Of course not. If we all only ever stuck with what we already know we like we'd all still be consuming nothing but macaroni and cheese and apple juice. But that's the beauty of instincts. They not only tell you what you like and don't like right now; they can also be a beacon, drawing you toward the next thing you could learn to like, your next palate-expanding adventure. If you just learn to heed that almost physical tug and follow where it leads.

"If you see something, say something."

–DEPARTMENT OF HOMELAND SECURITY

Ok, so how do we make our taste? Follow our instincts? Well, one very good way is through language. Say you spend Saturday afternoon at a museum or your lunch hour browsing art blogs, and somewhere in there you see something you really like. Something that makes your eyes and brain light up like a Christmas tree. **Use your words.** You could actually write it down, or tell a friend, or you could just articulate it to yourself inside your head.

What is the artist's name?

Frida Kahlo.

To what period/era/style/movement does she belong?

Twentieth-century Mexican surrealism.

In simple terms, what is it you like about the art?

The colors. The strangeness. The feeling it gives me.

Dig a little deeper. What about the colors?

Their vibrancy.

What about the subject?

Its female-centeredness.

What does it make you feel?

Curiosity. Fear. Bliss.

Just use regular old English for now. In time you may pick up some more technical language, but it's not important at this stage. Just from the short self-interview above, you already have half a dozen leads to follow: Kahlo, surrealism, Mexican art, vibrancy, feminism, emotiveness.

As you start looking at more and more art, you can use the descriptive words to start to triangulate. Which of those factors do you find yourself drawn to consistently? Maybe you'll find you have a thing for twentieth-century Mexican painting. Maybe you'll find you don't give a crap about time or place, but you really care about use of color. Maybe you'll find five of those six leads are dead ends, and you really just like Kahlo. Either which way you are using language as blocks from which to construct the palace of your own taste. And that is a tremendous thing.

"... so good, and so twisty, and so shadowy, and so chewy, and so boomerangy, that it requires the forging of a new word for 'beauty.'"

–NICHOLSON BAKER

So, yes, it's very useful to use your words. But it is also the case that sometimes words will fail you. And that's ok. There are two main reasons this might happen:

The first, and best, is that you are just so blown away by something that words actually fail you. You just stand there with your mouth hanging open. And if someone were to come up to you and demand you put into language why it is you like so much this thing you're looking at, you would not be able to give them a coherent answer no matter how hard you

tried. Well, congratulations! You are having a more or less transcendent experience, and that beats, hands down, the opportunity to add one more brick to your language-based palace of knowledge.

Other times language might fail you not because you've had your socks knocked off but simply because you lack the necessary information. Say you see a painting you like used as décor in the lobby of a public building, or spot a cool mural from the window of a moving train, or notice some beautiful, anonymous hand-lettering used in an ad in a magazine. So you don't know who made this thing, and there's no easy way to figure out what style or school or movement it's a part of, and maybe you even saw it so briefly you're not even sure exactly what it was about it that caught your eye. Well that's ok too. Simply, the more you appreciate the better.

Even when you lack the words to say why it is you like what you like, **you are training your brain to like, to like what it likes, and to know what it likes.** And major kudos are due to you for that.

LET'S TALK
ABOUT
MUSEUMS

Let's get one thing straight right away: Art museums are there for you—yes, you. Not only for little kids on field trips, not only for golden-agers with memberships, not only for snobs or scholars or super-duper-knowledgeable people. For you. And you and you and you. For everyone. Seriously. Are they often overpriced? Yes. Can everyone afford to go? No, they cannot. But nearly every museum has free days or free evenings or *something* to help folks who may not have the cash flow to come and see the art. **You are 100% entitled to be there.** No ifs, ands, or buts.

A WORD ABOUT WALL TEXT
AND AUDIO GUIDES

As you probably know, museums generally have labels on the walls offering basic, and sometimes more extensive, information about what you're looking at. Similarly, many museums offer audio tours so you can listen to info about the art via headset as you walk around. You are allowed to love and utilize the heck out of these tools. But you are also allowed to ignore them completely and not use them at all. Or you are allowed to have mixed feelings about them—using them sometimes and not others just depending on the mood you're in. Or perhaps you'd like to walk through the show twice: first using the wall text or audio guide to gather knowledge and then a second time using your recently absorbed knowledge to better appreciate the art. Or first having a pure, unmediated experience of the art and then following that up with some knowledge acquisition. Point being, there is no one right way to do it. Do what feels right to you.

A blockbuster art show comes to the museum in your town. You know the type of thing—it features the work of an artist who's more or less a household name. Picasso. Van Gogh. Your most self-consciously cultured friend goes immediately and talks about it. A lot. You think, "I should go to that." But, hey, it's going to be there for months; you've got plenty of time. But then suddenly you look up to discover it's the closing weekend, you never did make it out to the thing, and now you've got too many plans to catch it. You miss the show and feel bad. The next show comes to town. Wash, rinse, repeat.

Boo! Fie on that. **There are two important but simple secrets that, if you discover, believe, and fully internalize them, will save you from ever having to have this irksome experience again.** Ready? Here they are:

SECRET #1: You have time to go to the big blockbuster art shows, if you want to.

SECRET #2: You don't have to go to the big blockbuster art shows, if you don't want to.

Reading this sentence gives you official permission to either make the time or blow it off, as you choose.

"People don't do this kind
of thing because they have
all kinds of extra time and
energy for it; they do this
kind of thing because their
creativity matters to them
enough that they are willing
to make all kinds of extra
sacrifices for it. Unless you
come from landed gentry,
that's what everyone does."

–ELIZABETH GILBERT

Do we all feel way way way too busy almost all the time? Yes.

Do we still find time to watch TV? Yes.

Do we find time to help our partner or child or parent or friend with something they need help with? Get that extra big project done for work? Feed ourselves? Breathe in and out? Yes, yes, yes, and yes.

We make the time to do the things we consider worth doing. If you love Matisse and you articulate to yourself that making it to the big Matisse show at the museum is a priority for you, you will make it happen. Take your whole family one weekend, call in sick to work one Tuesday, get a babysitter the one evening the museum is open late. Stop doing whatever it is you are doing most of the time and do this instead. Whatever it was will still be there when you get back to it. Promise.

Well, for one thing, no one cares. Seriously. Does anyone but you care if you go to this thing or not? No! They do not! Your relationship with art is not public property. While art can, and most likely will, open up new ways for you to relate to the people around you, your connection with art is personal. It's really nobody's business but your own.

So there is really only one question to answer: Deep down, in your heart of hearts, **do you want to see it or do you not actually care about seeing it?** If you want to see it, see previous page, and see it. If you don't care about seeing it, and are only racked with guilt because you think you *should* go, get over it. Say loudly and clearly to yourself: I don't care about seeing that, and I am not going to go. Then move on with your life. Do not give it another thought. But do move along to what you *do* want to see.

And don't worry that just because you have decided not to go to that one thing, you will never go to anything or see any art ever again and that you are a philistine and a heathen. Honestly, just stop it. **There are about a million other places you can see art besides big museum shows.** Come on, you know this. We'll talk about two of the biggies—galleries and your own home (yes, really)—in detail soon, but first, here are a few other ideas about how to enjoy museums.

"I can wish the traveler no better fortune than to stroll forth in the early evening with as large a reserve of ignorance as my own."

–HENRY JAMES

One of the problems with the rise of blockbuster shows in museum programming (as ubiquitous as these seem today, they're actually a relatively recent phenomenon) is that they tend to overshadow all the other super-cool stuff that's on view in every single museum *all the time*.

Like, oh darn, you missed that big Matisse show at the modern art museum. But guess what? That museum may have something by Matisse lurking around there somewhere in the permanent collection. And something by Picasso and something by Albers and something by Frankenthaler and then about a thousand rad things by people you may never have heard of. **All kinds of great stuff just hanging on the wall. Right. Now.**

Most municipalities ranging from midsized towns to major cities have some sort of art museum either in them or nearby. So odds are good there is somewhere near you where you can go and look at art. Likewise, unless it's one of those tropical lie-on-the-beach-and-do-nothing-type numbers, going to museums is something people tend to do when they're on vacation in a new place.

How you look at the art in the permanent collection of a museum will depend a lot on how often you plan to visit that particular spot. If it's in your hometown and you aim to start going there regularly (and, in spite of costs, doing so really could be achievable: Lots of smaller museums are more affordable, or even free, and lots of public libraries actually loan out museum passes—true story!), take your time. Just choose a room or two each time you go and spend some time enjoying each thing before moving on to the next. You can choose these rooms almost at random. No need to worry about being sure to hit the best or most interesting stuff, because you'll make it around to everything eventually. You've got all the time in the world. Just pause in front of whatever and stare at it for at least half a minute and see how it makes you feel.

On the other hand, if you're in a far-off city that you may not visit again anytime soon, you're most likely going to want to hit the highlights. A few people might be Zen enough to still use the more relaxed, just-pick-a-room, whatever-you-see-will-probably-be-great, easygoing method. But most of us are too afflicted with Fear of Missing Out to find that bearable. If we know we're in the same building with the gosh darn *Mona Lisa*, we're going to need to see it. This is where getting a map, selecting a handful of your must-see pieces, and planning a route to take you to each one in turn becomes a good idea. And, good news, on your way from one Really Famous Thing to the next you'll find yourself walking past loads and loads of other amazing things and getting to enjoy those as well. Bonus!

This one might seem super weird, but it comes in handy. Sometimes instead of looking at art, it's fun to look at other people looking at art. Next time you're in a museum or other art-viewing venue take a step back and do a bit of people watching. Notice the different ages and types of people drawn to different kinds of art. **Notice how everyone has their own way of walking around, stopping, starting, pausing, lingering, powering through.** Who stops and stares for a super-long time? Who hardly seems to look at anything at all? Who looks at their phone more than the art? Who can't stop talking? Who rushes ahead? Who trails behind?

But don't judge. Everyone is different and that's not a bad thing—just because someone cruises though quickly doesn't mean they might not be having their own personal best art-viewing experience. Think about what constitutes your own optimum art encounter.

WHAT IF THERE ARE NO MUSEUMS WHERE I LIVE?

If you live in a small town or a rural area or anyplace where there is no art museum nearby, you have two options. Both equally valid. Both conducive to art happiness. It's just a question of which suits you best.

OPTION #1: You can just not worry about it. Instead, avail yourself of the myriad ways of looking at art without leaving your own home (more on that in a bit).

OPTION #2: You can make it a point to go where there are museums. Choose your vacation destinations, weekend getaway spots, even Saturday afternoon drives based on the locations of art you'd like to visit. This is that thing about making something a priority. If you make this a priority it can totally happen.

So it's really just a question: Do you want to make your relationship with art an easy friendship or a bold adventure? Because both are valid. Of course, you can also mix and match these two tactics. **Stay home when you feel like staying home and go forth when you feel like going forth.** The combo would be a good bet for a lot of people.

"I saw the buildings along the main street and it seemed they had a message for me, something concerning the temporary, and playful, and joyously improbable nature of the world."

–ALICE MUNRO

Cities and towns increasingly have public art programs. Whether publicly funded at a city, state, or federal level or run through local nonprofit arts organizations, these programs work to place artworks—often durable things like sculpture, but sometimes also interactive pieces or even things with a performance component—in public places where anyone passing by can enjoy them. And

many municipalities now require that a percentage of funds for any major new building project must be spent on some sort of public art. Suffice to say, **this stuff exists.** You can find public art in your city, or cities you visit, pretty easily online. Public art programs often have not only websites, but interactive maps, databases, or apps. Other great online resources for finding public art include the websites of the Public Art Archive, Culture-NOW, and the Arts Services Directory of Americans for the Arts.

And then there's street art. Once derided as nothing more than vandalism, graffiti has been embraced and celebrated as the art form it so very often can be. From whole alleys full of large-scale murals to tiny paste-ups and sticker art, there is a lot of cool stuff to be seen out there on the street. There is, of course, also random vandalism and tagging that you may or may not personally find attractive. But if you open your mind to the possibilities of street art, and do a bit of research to find out where in your town exciting work is happening, there is suddenly a lot more very vibrant art just hanging around out in the world ready for you to come and take a look.

HOW
TO VISIT
ART GALLERIES

Now, you may very well have grown up being taken to museums, but most people never set foot in an art gallery until they are adults, and many not even then. Let's be honest and acknowledge right up front that visiting art galleries can be incredibly intimidating if you're not used to it.

If you have never done it, and the reason that you've never done it is that you are just really deeply not interested, great. In that case keep right on not doing it. But if you haven't done it, and the reason you haven't done it is that you're intimidated—or, if you have occasionally done it but feel little inclination to do it again due to intimidation—then please read on. **We're about to rid you of a source of fear and discomfort in your life and replace it with a source of amusement and joy.** And that's always a good thing.

With a few simple tools and a bit of preparation you can visit galleries like a champ.

Will the first time still be a bit weird and awkward? Almost certainly. But isn't that true of the first time doing nearly anything? Isn't that almost the point of doing things for the first time—so that you can experience the weirdness and awkwardness, even kind of revel in the fact that, well, hey, at least **it will never be quite this new and weird and awkward again**, and then proceed to learn and get better at said thing?

And bear in mind that the minor growing pains of this learning curve (which, let's be honest, is not all that steep—we're not talking rocket science here) will be well worth it when you have a new, virtually inexhaustible, ever-changing, and let's not forget *totally free* new way to look at art at your disposal.

WHEN?

Ok, let's get down to brass tacks. When should you go?

Well, which of these two things is more important to you?

A) an unimpeded, uninterrupted view of the art, *or*

B) minimization of potential social awkwardness?

If you answered

A) Visit galleries early in the afternoon, ideally on a weekday, though weekends are also okay.

B) Visit galleries on evenings when there are new show openings or neighborhood gallery walks.

In the first scenario you'll have the places almost entirely to yourself and can focus your attention on the art, but there will be at least a few inevitable run-ins with gallery personnel. In the second scenario there will almost always be at least a few people's heads between you and the art you'd like to look at, but no one will pay any attention to you at all. Plus, often: free wine.

WHERE?

Once you've decided when to go, per the previous, next figure out where you are going. You'll want an area that holds several galleries within walking distance of one another. Most good-sized towns will have such a neighborhood; most major cities will have several. Ask around to find out where they are, and then try each one if there's more than one—**each little collection of galleries will have its own character and flavor** and you'll pretty quickly figure out which one is most to your taste.

THE DETAILS

If possible, find out the names of the galleries in the area where you're headed and check their websites ahead of time for their hours (most don't open till eleven or noon), days they are closed each week (often arbitrary weekdays), and random days or weeks they may be closed while hanging a new show.

If you're going the show opening(s) and/or neighborhood art walk route (and these two things are often timed to happen on one and the same evening—the First Thursday or Last Saturday of each month or what have you), then do some Googling around to figure out the dates and times these events are happening. This part may actually be a bit tricky—art gallery associations tend to be a bit disorganized and/or prone to infighting, and their websites are often not well maintained. **Be persistent.** Look for Facebook groups. Your efforts will be immeasurably rewarded in avoided frustration—not showing up at places that are closed for the evening or the week or, oops, don't actually exist at all anymore.

"What you think of me is none of my business."

–KERI SMITH

Up to now we've been talking a lot about big-name famous artists—the kind of folks whose names feature in blockbuster shows, blue-chip museum collections, and at least vaguely in the memories of many if not most people. But of course there are loads and loads of art-works being made and displayed right this very minute by lots and lots of people you've never heard of. This is one of the great things about the gallery circuit—it's **a prime opportunity to see and learn about tons of spectacular stuff you would otherwise never discover.** But that you can now enjoy. And, to be fair, a goodly ton of stuff you won't enjoy, also. But that's useful too. Seeing art you don't like helps to keep you ever refining your own taste and learning what you do like.

When talking about things like the gallery scene, people say "artsy fartsy" like it's a bad thing. But what if we embraced it? What if instead of a silly slur used to try to bully and shame people for their so-called pretension of liking art, we co-opted it to mean someone who likes art and is knowledgeable about it, without being either annoying or pretentious? If you think about it, "art fart" is kind of the perfect term for such a person because, after all, how pretentious can you really be if your name has the word "fart" in it? Answer: not very.

Once you've embraced your inner art fart you've effectively given yourself permission to go where the arty people go, look at stuff, absorb lots of new information about new art and artists, and distill what you like and don't like, all without ever having to worry that said endeavor is affected or obnoxious. Because, for one thing, it's not. And for another thing, your art happiness is no one's damn business but your own. So get out there.

"Vain trifles as they seem, clothes have, they say, more important offices than to merely keep us warm. They change our view of the world and the world's view of us."

—VIRGINIA WOOLF

Ok, if after all of this you still feel intimidated about going to galleries, here's what you do: Play dress-up. Disguise yourself as a ridiculously affluent art lover who isn't just a looky-loo—oh no, this person could actually whip out their credit card and buy a piece of art for many thousands of dollars right now if they felt like it. Of course, that's not likely to happen because, along with their enormous bank account, this person also has incredibly particular taste. Very little pleases them.

Now if you're thinking, oh, well, sure, but how am I supposed to do that when I do not have designer clothes and whatnot? That's where you're forgetting one important little secret: Rich people, especially the arty ones, don't dress the way we think rich people dress (reason being: we're actually thinking of celebrities, who are different and whose job it is to wear designer stuff every day). **If you want to pretend to be a serious art buyer, you can almost certainly do it with things you have in your closet right now.** Oh, and the nice thing about this costume is that it's unisex—works equally well on boys and girls.

Here's what you wear:

A black shirt. A thin, loose, stretched-out tee shirt is best, but a button-up shirt, turtleneck, or stretchy long-sleeved thing also works.

Your most trashed pair of jeans. Seriously, the more trashed the better—holes and rips? Great! Paint splatters? Even better! Do you garden? Wear the pants you garden in, ideally before washing them. This may sound crazy, but the logic is sound: Only someone totally confident in his or her right to be there would wear hobo pants to an art gallery. You are doing it. Ergo, you belong.

The one nicest thing you own. Did you pop for really nice heels for your wedding? Wear those. Do you own one good suit? Wear the jacket. Did you finally break down and buy a decent pair of sunglasses or bag? That's the ticket. Do you own an actual piece of really nice jewelry? There you go (but it does need to be *really* nice). You might be able to layer on two such items if you're lucky enough to have them, but don't go overboard.

Thus decked out, waltz in like you own the place and frown at all people and objects you see. You are an actor. Project confidence, boredom, and dissatisfaction. Meanwhile, inside the privacy of your own brain you can be enjoying the hell out of the art you see.

HOW TO
LOOK AT ART
WITHOUT
LEAVING YOUR
HOUSE

"The paradise of forms and colors is always accessible."

–THICH NHAT HANH

As much as there is to be said for getting out there in the world where art is happening, there is also quite a lot to be said for enjoying art from the comfort of your own home. No need to brave the crowds, no need to brave the weather. No need to look for parking. No need to feel intimidated or fight off intimidation. **Just you and art enjoying a dialogue in the place where you feel most at ease and most yourself.** Make some tea or pour some wine, pull up a chair, put up your feet, and enjoy!

"With freedom, books, flowers, and the moon, who could not be happy?"

–OSCAR WILDE

So, chances are this is not the first book you have ever bought with the word "art" in its title or subject heading. Right? If you have even a passing affection for art and even a passing interest in books, odds are you've picked up an art book or two somewhere along the way. For one thing, they're pretty ubiquitous gifts, so someone has probably given you one at some point or another. The odds are equally high, if not even higher, that said art books are currently either sitting on a bookshelf or attractively arranged on the coffee table—either way, not being looked at and gathering dust. And even if you own no art books, get some from the library and proceed with this cool trick. The nicest and easiest way to look at art at home:

- Go to kitchen and obtain snack and/or beverage of your choice.

- Go to bookshelf or coffee table and extract art volume, more or less at random.

- Take refreshments and art book to sofa or table (depending on size of book).

- Slowly, slowly page through book while enjoying refreshments. Stretch it out. Try to make this process last half an hour. **Really look at each image and enjoy it.**

- If, at the end of thirty minutes, you are happy with what you have seen, return book to shelf, give it a gentle pat, and tell it you'll see it again soon.

- If, on the other hand, you have not enjoyed this book—and remember, be honest, no cheating and pretending you enjoyed it just because you think you *should* have done so—get rid of it. Put it in the donation pile or sell it or leave it on the street corner. Seriously. Someone else may get some good out of it, and you won't have it cluttering up your house.

- Another day, repeat with another book.

No matter what sort of art you like—or even if you don't yet know what kind of art you like—there are copious online resources available at your fingertips. Up-and-coming painters and illustrators? Modern photography? Contemporary fine art? Work from previous eras? Art from a particular region or culture? Sculpture? Performance? Outsider art? Graffiti? Comics? Art criticism and theory? Art history? Whatever floats your boat, it's more or less guaranteed that with a little bit of digging you can find numerous high-quality blogs on the subject. Sites run by passionate individuals determined to put new work in front of your eyeballs. Every. Single. Day.

And then there are the more formal and official sites you can avail yourself of as well. More and more museums are digitizing their entire collections, which means you can look at sparkling high-res images, not only of the work they generally display, but also of the loads and loads of amazing stuff most museums have in their possession but rarely, if ever, have room to show

to the public. This means **you can actually look at *more* world-class art in bed in your PJs than you could if you trekked to Paris or Rome or Kyoto.** Humongous international galleries like Saatchi also have amazing websites full of goodies, and Artsy.net is not to be missed.

Devote a Saturday afternoon or Sunday evening to researching the best art websites for you, and you'll be richly rewarded. Soon you'll be in possession of a list of bookmarks that you can dip into with ease anytime to feast your eyes upon artwork that makes your brain tingle. Not too shabby for a few hours' work.

The task of hanging things up on the walls of one's home can be incredibly daunting. We've all known people who still didn't have anything on the walls of their "new" place, even though they'd actually lived there for a couple of years—not because they didn't want things up on their walls to look at, but because they were paralyzed by indecision or fear of screwing up. Let's not be those people, ok? Let's boldly purchase art we like and boldly hang it up. Okay? Okay!

Wait a minute, you may be saying to yourself, did that just say "purchase art"? What the heck? There's no way I can afford to buy actual real live art! Come on!

But that's where you're wrong. **One of the most awesome things of the past ten years or so is the proliferation of easily accessible, affordable art that you—yes, you!—can own.** Don't believe it? Google "affordable original art" or "affordable art prints" and see for yourself!

A little vocab:

"Original art" is one of a kind: the actual pieces of paper or canvas or whatnot that the artists themselves used their hands to make marks upon with their paints or pencils or whatever.

"Prints" can mean one of two things: The meaning you will find most often if you shop for art online is reproductions—multiple high-quality copies of an artwork like what you would get if you printed them with your computer printer, except generally (we hope) made with a much nice printer on much nicer paper and usually signed by the artist. The other meaning is multiple originals made by the artist using techniques such as woodcut, etching, lithography, or photography. Either way prints are, understandably, generally cheaper than one-of-a-kind originals, but both can be affordable, both can be of good quality, and both can make you really happy every time you look at them hanging there on your wall for years to come.

And then there are loads of other great visual things that may not be fancy but represent art you like—**postcards** or a **poster** you bought in the museum gift shop, the **flyer** from a show you loved: Basically any piece of paper that holds the image of an artwork you care about is fair game here.

Once you have a piece, or pieces, of art that you like in your possession, don't delay! Delay is the enemy. Measure it, get a frame to fit it (and a matte, if needed— you could even pop for having it professionally framed, but that does get pretty pricey pretty quick), wander around your pad with the art in the frame holding it up here and there until you find the spot it seems most at home in, hammer a nail into the wall (security deposits be damned!), and hang the darn thing up. Walk past it. See it. Smile. Repeat.

TALKING

ABOUT ART

What people who talk about art at cocktail parties
know that you don't:

Not much.

Yes, now and then you're going to meet a super smarty-pants art person. A true intellectual who knows lots and lots more about art than you do.

And out of the few such people you meet, some will be modest and keep much of their knowledge to themselves so you may never even realize how wicked art smart they are, some (the smallest group, honestly) will share interesting information with you in a fascinating and unintimidating way, while a third group will feel the need (born, almost surely, out of their own insecurities) to show off to you how much they know and make you feel bad about how much you don't.

And do you know what the single simple solution for dealing with the people in that third category is? Don't talk to them about art. Just don't. Talk to them about beer or baseball or fashion or books or TV or the weather or any other damn thing you can think of. **Don't get sucked into their one-upmanship game because it will just make you feel like crap.** Which is what it's designed to do. Okay? Okay.

"I will not be just a tourist in the world of images."

—ANAÏS NIN

But, in truth, the number of people who want to use their extensive knowledge to make you feel bad is very small. Most of the people you encounter at parties and the like whom you perceive as being so much more knowledgeable than you are about art aren't. Not really. They've just gotten good at one thing: name-dropping. **Name-dropping sounds like a bad thing, but it is actually based on a very useful and practical trick:** Name retention. Remembering names is a very useful life skill. And when it comes to talking about art and sounding smart it will serve you incredibly well.

" '. . . the company of clever, well-informed people, who have a great deal of conversation; that is what I call good company.'

'You are mistaken,' said he gently, 'that is not good company, that is the best.' "

–JANE AUSTEN

It's like they told you in French or Spanish class—the best way to learn a new language is through conversational immersion. Find some people, ideally "clever, well-informed people," with whom you can talk about art. This could be a deliberate endeavor, like a little club that meets for lunch or dinner once a month for art

chat, or it could be a much more casual thing where you just bear in mind that art makes a great topic when you have the chance to talk with someone intriguing.

Here are some tips for engaging people in interesting, nonintimidating conversations about art:

It probably goes without saying, but just to be super clear let's say it anyway: no assholes.

Assume a level playing field. Maybe they know more than you and maybe you know more than them, but for the purposes of this conversation you are having right now you should **work from a baseline assumption of equality.** This will make everyone much more comfortable.

Speak up. Don't feel shy about stating your tastes, opinions, and preferences. Practice talking art smart. Use proper names. Everyone may not agree with your taste. Heck, if it's an interesting conversation, everyone *won't* agree. But as long as you've followed Rule #1 above, differences of opinion should just result in good, old-fashioned interesting conversation of the kind that Ms. Jane Austen would heartily approve.

Ask questions. Just remember: If you sometimes feel shy, other people feel shy too. The more you can do to draw out others, the more you can learn and discover from them. The more new artists you can hear about. The more new opinions you can be exposed to. The more different kinds of talking about art you can be exposed to. Plus, not feeling the pressure to do all the talking yourself will put you at ease and make everything more fun for everyone.

You know what's fun? Seeing art with other people. Think about the people you like and plan some time for Art with Friends. The best person to go look at art with is someone with **curiosity, openness, and of course a healthy interest in creative endeavors.** But maybe don't take your most self-consciously cultured friend (you know, the one who makes you feel bad about all those big shows you missed). It should be someone you feel comfortable with, someone you can laugh with. Because experiencing art with others is interesting and weird and funny. You gain insight not only into the art you're looking at together but also into your pal's sensibility (what they care about, what strikes them) and your own sensibility as well (where it syncs up with and where it diverges from your friend's). Not to mention, having a date on the calendar with another actual human being is a really good way to get yourself out there to do and see things you might otherwise miss. And talking out loud with someone about what you're seeing is a great way to help ensure you'll remember it later.

"I don't think it should be socially acceptable for people to say they are 'bad with names.' No one is bad with names. That is not a real thing. Not knowing people's names isn't a neurological condition; it's a choice. You choose not to make learning people's names a priority."

—MINDY KALING

Most people have a hard time remembering proper names. If you say you're "bad with names," all you're really saying is that you're a human being. That said, this isn't a serious impairment—name retention is a muscle you can exercise and, if you're serious about it, strengthen and improve. The funny part, though, is that the more serious and effective a memory technique is, the goofier it appears. Here are some prime examples. **These techniques will seem super silly, but if you actually commit and deploy them they will immensely improve your ability to name-drop.**

Rhyming. Make up a goofy rhyme (really, the sillier the better here, because the dumber it is the more likely you are to remember it) incorporating the name:

Frank Stella, you're quite a colorful fella

Agnes Martin, your pictures seem to be departin'

Constantin Brancusi, those curves are making me woozy

Mary Cassatt, and all those children she's got

See? Totally stupid. Hilariously bad. And super hard to forget. Bam!

Alliteration. This one is good if what you struggle to remember is not only the name, but which artist's name goes with which art. Link them up alliteratively and watch the magic happen:

Caravaggio = **Car**-headlight-like lighting

Maya **L**in = **M**emorial **L**egacy

Degas = **D**ancers

Louise **F**ishman = **L**ightning-fast **F**ingers

Puns and visual storytelling. This is about creating a picture in your mind that pairs the name with a concrete object and thus gives you the clue you need to recall it. It works best with single words, like just last names:

> Picture one of Louise **Bourgeois**'s enormous metal spiders as a member of the French **bourgeoisie**, complete with long white stockings and a silly floppy hat.

> Imagine Robert **Motherwell** in the context of a coming out story: "**Mother, well**, I just have to tell you: I really love enormous black-and-white abstract canvases."

> Envision **Wile E.** Coyote as the subject of one of Kehinde **Wiley**'s portraits.

EXTRA CREDIT: MAKE YOUR OWN ART!

"You're an artist when you say you are, and you're a good artist when you make somebody else experience or feel something deep or unexpected."

–AMANDA PALMER

Here's a crazy notion—don't just look at art, don't just appreciate art, teach yourself to make art! Yes! It can be done. A lot of people would like to be more creative than they're currently being, but they're afraid they don't have enough talent or enough time or enough of something else. But you *do* have enough. You *are* enough. Take everything you've learned so far about making space in your life for art and use it to start making something of your own. **It will be good for your brain and your heart and your soul.** Here are a few ideas for how to make that happen.

"In art and dream you may proceed with abandon."

–PATTI SMITH

If you have kids yourself this is super easy; if you don't, you'll have to ask around and find a family of your acquaintance who will let you come spend an afternoon with them. Spread newspapers out on the table, get out lots of paper and paints and paintbrushes (buy cool new supplies for this and watch your popularity soar), and go nuts. Watch how children paint—**the ease and freedom and relative absence of premeditation that goes into their art making**—and do your best to emulate a little bit of that true flow.

"Draw what you live so you will live it more deeply."

–DANNY GREGORY

Pick a time—first thing in the morning, on your lunch break, before you turn on the TV at night—and sit down with paper and pencil at that same time every day for seven days. Draw whatever is in front of you. Slowly. **Draw the lines your eyeballs actually see, not the shapes your brain tells you to expect to be there.** Don't be surprised if you look up to discover an hour has passed instead of fifteen minutes—this is incredibly soothing and meditative, and therefore addictive.

THE CANON
SUPER-SIMPLIFIED
SO YOU CAN
FINALLY STOP
FEELING BAD
ABOUT YOUR LACK
OF KNOWLEDGE
ABOUT THAT

For better or worse, it is most often Western painting from about the fifteenth through the twentieth centuries that gets hauled out to make people feel bad about their lack of knowledge because they didn't go to art school or study art history or whatever.

Obviously there is way way *way* more important and beautiful art out there than just what falls into that relatively tight circle—art in all sorts of media from all over the world and all throughout time. Which is actually why having a handy cheat sheet such as the following one on the traditional mostly white, mostly male, mostly painters "canon" is nice—**you can learn it or refer to it as you see fit or as needed, and free up a lot of time and energy previously used for fretting and feeling inferior for discovering new art and artists** (both inside and outside of this ecosystem) that make you happy.

Ok, so here goes, the basic periods in the traditional Western art canon (starting off in Europe and later moving to include the United States) and the biggest of big names associated with them:

5TH TO 15TH CENTURIES	MEDIEVAL
15TH AND 16TH CENTURIES	RENAISSANCE
15TH AND 16TH CENTURIES	NORTHERN RENAISSANCE
16TH CENTURY	MANNERISM
17TH AND 18TH CENTURIES	BAROQUE
18TH AND 19TH CENTURIES	ROMANTICISM
19TH CENTURY	IMPRESSIONISM
19TH CENTURY	POSTIMPRESSIONISM
1900s–1930s	EXPRESSIONISM
1910s–1950s	CUBISM
1910s–1950s	SURREALISM
1940s–1950s	ABSTRACT EXPRESSIONISM
1960s	POP ART
1970s ON	POSTMODERNISM

GIOTTO

LEONARDO DA VINCI, MICHELANGELO, RAPHAEL

PIETER BRUEGEL, HIERONYMUS BOSCH

EL GRECO

JOHANNES VERMEER, CARAVAGGIO, PETER PAUL RUBENS, REMBRANDT

J. M. W. TURNER, FRANCISCO GOYA

CLAUDE MONET, ÉDOUARD MANET, PIERRE-AUGUSTE RENOIR,
MARY CASSATT, EDGAR DEGAS

VINCENT VAN GOGH, PAUL GAUGUIN, PAUL CÉZANNE, GEORGES SEURAT

HENRI MATISSE, WASSILY KANDINSKY

PABLO PICASSO

SALVADOR DALÍ, RENÉ MAGRITTE, FRIDA KAHLO

JACKSON POLLOCK, MARK ROTHKO, HELEN FRANKENTHALER

ANDY WARHOL, JEAN-MICHEL BASQUIAT, ROY LICHTENSTEIN

JEFF KOONS, DAMIEN HIRST, BARBARA KRUGER, CINDY SHERMAN,
GERHARD RICHTER

ACKNOWLEDGMENTS

Thank you to my fabulous editor, Christina Amini, not only for getting me to get off my butt and write this book, but also for being a wonderful friend and all-around lovely person. Thank you to the whole amazing gang at Chronicle Books, including (but not limited to!) Mirabelle, Vanessa, Marie, Tera, Steve K., Diane, Sandy, Sarah G., Sarah M., Erin, Kristen, Brooke, Michael C., Ana, Caitlin, Wynn, and Mark. Thank you to the smart women who bolster me up and delight me daily with their existence—Shweta Jha, Casey Daniel, Vanessa Walden, and Kristen Eksouzian. Deep thanks to my parents for having instilled a love of art in my soul from a very early age—I'm not sure if there's any greater gift you can give a kid, honestly. Thank you to the fine folks at the Cup of Joe Coffeehouse and Jane bakery, and thank you to that college art history professor who almost failed me and made me realize I needed to find a better way. And greatest thanks of all to Mabel and Bill, who make me ridiculously happy every single day.

Austen, Jane. *Persuasion*. London: Vintage, 2014.

Baker, Nicholson. *The Anthologist*. New York: Simon and Schuster, 2009.

Brown, Brené. *Daring Greatly: How the Courage to Be Vulnerable Transforms the Way We Live, Love, Parent, and Lead*. New York: Avery, 2012.

Caruso, Iyna. "Art's Healing Powers." Saturdayevening post.com. www.saturdayeveningpost.com/2009 /01/01/in-the-magazine/health-in-the-magazine /arts-healing-powers.html.

Chimero, Frank. "The Only Note to Self." Frank Chimero.com (blog). frankchimero.com/writing //the-only-note-to-self/.

Department of Homeland Security. "If You See Something, Say Something." www.dhs.gov /see-something-say-something.

Gilbert, Elizabeth. *Big Magic: Creative Living Beyond Fear*. New York: Riverhead, 2015.

Giocondo, Giovanni. "A Letter to the Most Illustrious the Contessina Allagia degli Aldobrandeschi, Written Christmas Eve Anno Domini 1513." In *Tasha Tudor: Forever Christmas* by Harry Davis. New York: Little Brown, 1984.

Gopnik, Adam. *Winter: Five Windows on the Season.* Toronto: Anasi, 2011.

Gregory, Danny. "Too Hot Not to Cool Down." Danny gregorysblog.com (blog). dannygregorysblog.com /2006/05/21/too-hot-not-to-cool-down/.

James, Henry. *Henry James: Collected Travel Writings: Great Britain and America.* New York: Library of America, 1993.

Kaling, Mindy. *Is Everyone Hanging Out Without Me? (and Other Concerns).* New York: Three Rivers, 2012.

Munro, Alice. *Lives of Girls and Women.* New York: Signet, 1974.

Nichols, Wallace J. "The Cognitive Benefits of Being by Water." *Blue Mind Blog.* www.wallacejnichols.org/144 /554/the-cognitive-benefits-of-being-by-water.html.

Nin, Anaïs. *The Diary of Anaïs Nin.* Vol. 1, *1947–1955.* New York: Mariner, 1975.

Palmer, Amanda. *The Art of Asking: How I Learned to Stop Worrying and Let People Help.* New York: Grand Central, 2014.

Schulte, Brigid. *Overwhelmed: How to Work, Love, and Play When No One Has the Time*. New York: Picador, 2014.

Smith, Keri. "New Shoes, New Life." KeriSmith.com (blog). www.kerismith.com/blog/new-shoes-new-life/.

Smith, Patti. *Early Work: 1970–1979*. New York: W. W. Norton, 1994.

Schiller, Friedrich. *Complete Poetical Works and Plays of Friedrich Schiller*. East Sussex: Delphi Classics, 2013.

Thich, Nhat Hanh. *You Are Here: Discovering the Magic of the Present Moment*. Boulder: Shambhala, 2010.

Tucker, Abigail. "How Does the Brain Process Art?" Smithsonian.com. www.smithsonianmag.com /science-nature/how-does-the-brain-process-art.

Warhol, Andy, and Pat Hackett. *Andy Warhol's Party Book*. New York: Crown, 1988.

Whyte, David. "Sweet Darkness" (poem). In *The House of Belonging*. Langley: Many Rivers, 1996.

Wilde, Oscar. *De Profundis and Other Prison Writings*. New York: Penguin, 2013.

Woolf, Virginia. *Orlando: A Biography*. New York: Harcourt Brace Jovanovich, 1973.

ART HAPPINESS